TIBETAN CALLIGRAPHY

T0060149

TIBETAN CALLIGRAPHY

HOW TO WRITE THE ALPHABET AND MORE

SANJE ELLIOTT

Wisdom

Wisdom Publications
199 Elm Street
Somerville MA 02144 USA
wisdomexperience.org

© 2021 Frank Sanje Elliott
All rights reserved.

No part of this book may be reproduced in any form or by any means,
electronic or mechanical, including photography, recording, or by any
information storage and retrieval system or technologies now known
or later developed, without permission in writing from the publisher.

Library of Congress Cataloging-in-Publication Data
Elliott, Sanje.
 Tibetan calligraphy : how to write the alphabet and more
/ Sanje Elliott.
 p. cm.
 ISBN 0-86171-699-X (pbk. : alk. paper)
 1. Calligraphy, Tibetan—Technique. I. Title.
 NK3639.T533E45 2011
 745.6'199515—dc23
 2011039573

ISBN 978-0-86171-699-9 eBook ISBN 978-1-61429-028-5

25 24 23 22 21
7 6 5 4 3

Cover design by Phil Pascuzzo.
Interior design by Gopa & Ted2, Inc.
Set in Arno Pro 11.25/16.
"As Long as Space Exits" on page 9 and "The Four Noble Truths"
on page 82 are by Tashi Mannox and are used by permission.
The photographs on pages 12, 14, 16, 17, and 18 are by Tendrel Photography.
The art and photography on pages x, 3, 7, and 8 are by the author.

Wisdom Publications' books are printed on acid-free paper and meet the
guidelines for permanence and durability of the Production Guidelines for
Book Longevity of the Council on Library Resources.

Printed in the United States of America.

MIX
Paper from
responsible sources
FSC® C011935

Please visit fscus.org.

This book is dedicated to bodhichitta,

the wish that each and every being may achieve enlightenment,

becoming free from the causes of suffering

and suffused with the causes of true happiness.

TABLE OF CONTENTS

FOREWORD

TIBET IN THE SEVENTH CENTURY was at the height of its political, economic, and military might, with influence throughout much of Asia and the subcontinent. The great King Songtsen Gampo (617–90) had married two Buddhist princesses (considered to be emanations of Green and White Tara), and under their influence Buddhism was flourishing as well. Soon, the king recognized the need of a written script for both his statecraft and to support the spread of Buddhism. He therefore decided to send his prime minister, Thönmi Sambhota, to study in India at the great Buddhist university of Nalanda for some years. Upon his return, Sambhota worked on developing a system of writing that would accommodate the needs of Tibetans and of Buddhism. So it is Sambhota that is credited with the creation of the alphabet and writing system that is still in use.

Anam Thubten Rinpoche writes:

Skill in calligraphy was highly regarded as an important subject of study in society. It not only served the holy scriptures, but helped the individual in his or her daily life. The position of Calligrapher elevated one to aristocratic status, and the lifestyle enjoyed as such was far beyond that of the common person. In public schools calligraphy became one of the main subjects of study. At Mindroling monastery [for example], it took six years to graduate in calligraphy.

Tibetan calligraphy continued to evolve over time to include many styles and characters, and its practice is still considered to be a component of one of the ten arts and sciences that relate to individual spiritual practice. The practice ranges from the foundation of perfect penmanship, to the most elaborate and creative flourishes, to the simple strokes of a mind at ease. Above all, calligraphy holds and transmits the word of the Buddha in all its many manifestations,

and thus embodies a worthy object of refuge: the Jewel of the Dharma.

Now for us it may seem that the art of Tibetan calligraphy has bifurcated into the two worlds of unicode font geeks and tattoo parlors. But let us not lose sight so easily of this important practice. The written word contains much magic beyond being a simple, or complicated, conveyance of information. Ancient spiritual traditions have always recognized the power of the word, both as utterance and as symbol. The great Buddhist languages, such as Sanskrit, Pali, and Tibetan, manifest this power both explicitly and implicitly. In studying the Buddhist teachings, one has many ways of relating to the media of its transmission. Not the least of these methods is simply beautiful writing.

There is no one more capable of conveying this than Sanje Elliott. A great artist in his own right, he has studied and taught the art of Tibetan thangka painting for many years. He has mastered the traditional, highly refined styles of Tibet and at the same time devel-

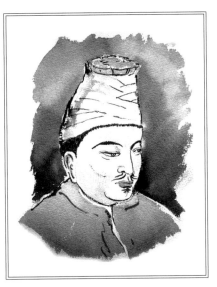

oped his own creative interpretations. Now in this book of traditional calligraphy, we too can learn the necessary foundation of Tibetan writing, perhaps in order to explore later our own creative relationship with the language. I am grateful for this needed addition to the field and will use it immediately in teaching Tibetan.

—Sarah Harding

SARAH HARDING has been the director of the Tibetan Language Correspondence Course since 1987 and an associate professor at Naropa University since 1992. Some of her books include *Creation and Completion*; *Machik's Complete Explanation*; *The Life and Revelations of Pema Lingpa*; and *Niguma: Lady of Illusion*.

Above: Thönmi Sambhota, creator of the uchen alphabet.

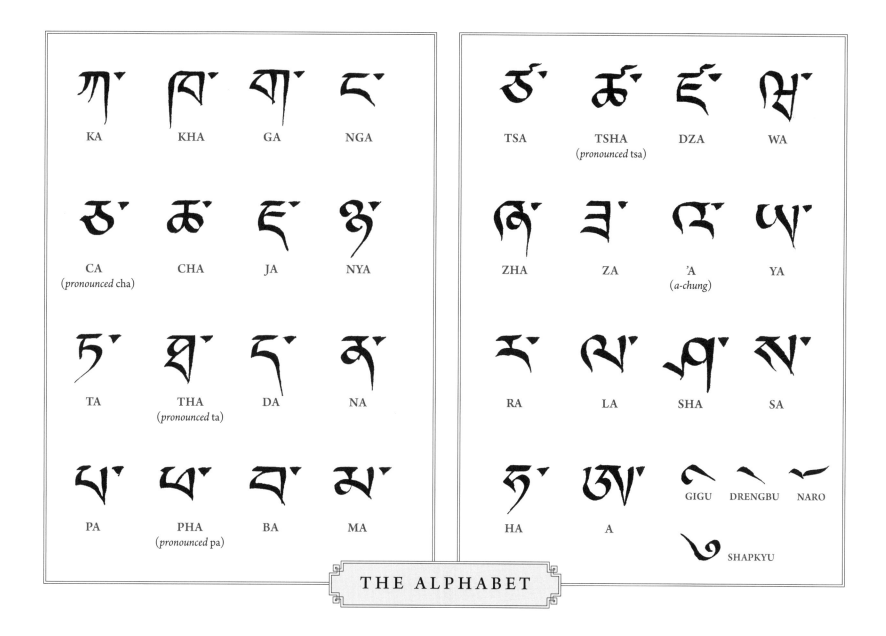

KA KHA GA NGA

CA CHA JA NYA
(pronounced cha)

TA THA DA NA
 (pronounced ta)

PA PHA BA MA
 (pronounced pa)

TSA TSHA DZA WA
 (pronounced tsa)

ZHA ZA 'A YA
 (a-chung)

RA LA SHA SA

HA A GIGU DRENGBU NARO

SHAPKYU

THE ALPHABET

INTRODUCTION

THE GOAL OF THIS BOOK is to introduce the classical *uchen* alphabet to Western students of Tibetan and to Tibetans growing up in the West, showing how the flat-edged pen is our equivalent to the reed pen that is the basic beginning tool of Tibetan monks and children. Unlike Chinese and Japanese characters, which are written with a brush, the forms of Tibetan letters are based on Sanskrit letters, which are meant to be written with a pen-like tool. It's true of course that the modern Tibetan master Chögyam Trungpa Rinpoche and those who were inspired by him did wonderfully innovative uchen letters using a brush (see Tashi Mannox's wonderful calligraphy on page 82), but this is a modern-day alternative to the classical uchen. Classical uchen has many similarities to classical roman letters, such as the crisp serif-like forms and the contrasting thicks and thins, all of which can be accomplished by a pen—or by a brush in the hands of a very skilled calligrapher.

One of the interesting differences between Tibetan and the roman alphabet is that roman letters sit on a baseline while Tibetan letters hang from a line, much like clothes from a clothesline. Another thing a student should be aware of is that the Tibetan alphabet employs no cases.

THE MANY USES OF THE TIBETAN ALPHABET

Gega Lama, in his book *Principles of Tibetan Art*, talks specifically about Tibetan letters and their usage:

There are an infinite variety of special techniques employing script: diagrams of magic circles for accomplishing various kinds of activity—pacifying, developing, influencing, or exorcising; protective charms and amulets worn on the body; charms to be eaten (as medicine or blessing); talismans against ritual pollution; protection against lightning; and so on. *The proper form of letters is very important, with many applications in this life and for future lives, since the desired effect can be achieved solely through the correct form of the letters, even though one does not read them aloud or even understand the meaning of the text. As is stated in the* Discourse Explaining the Perfection of Wisdom: The Replies of Kousika:

> When writing or reading
> The letters are the nirmanakaya (form aspect of enlightenment).

And,

> (Writing) large letters on a large surface
> Is equivalent, in terms of merit, to being a holder of the lineage.
> If the letters are precisely spaced and connected,
> One will become free from disabilities and diseases.
> If the letters are bold and clearly outlined,
> One's vision will become flawless.

Because Tibetan letters are deeply connected with Tibetan Buddhism, they are imbued with a power that is separate from their function as a phonetic alphabet. This tradition came from India beginning in the seventh century, where sacred mantras were written in Sanskrit, and from the ancient Indian practices of tantra and mantra.

Tantra is the esoteric system used by Hindu and Buddhist practitioners from the middle of the first millenium onward in India and Tibet, and also in Japan in the Shingon school. Tantra is said to be a form of practice that includes all of reality, that does not leave out negative or unwanted objects or mind patterns. Its literal meaning is "weaving together," so that our negativities are not swept under the carpet but instead used as fuel or energy to create their opposite positive effect. This is a kind of recycling or alchemy, where lower matter or energy is transmuted into a higher form: ordinary metals into gold. In the spiritual world this translates as turning ordinary mind into enlightened mind. Our enlightened mind or buddha nature has always been there, but we have just not realized it.

Mantra is the sound aspect of tantra: a mantra is a sound, syllable, word, or group of words that are considered capable of creating spiritual transformation. This sound can also be used as a means of focus

in meditation. The sound of a mantra is said to vibrate eternally and continue out into the far reaches of the universe. This is the function of a prayer flag that has mantras written on it, for instance. The wind blows the flag and starts the movement of the mantra outward, toward the galaxies.

The Tibetans are very fond of writing mantras and carving them into stone. The favorite is the mantra of the bodhisattva of compassion, Avalokiteshvara—OM MANI PADME HUM (which Tibetans pronounce as OM MANI PEMÉ HUNG). Avalokiteshvara is the patron deity of the Tibetan people and is believed to have been embodied in the early Tibetan kings and various Buddhist masters, such as the Dalai Lamas. This mantra is seen everywhere in Tibet and is also used in prayer wheels. These prayer wheels are either held in the hand and rotated constantly or installed in temples in ornamented cylinders that are turned by pilgrims in their circumambulations of the temple.

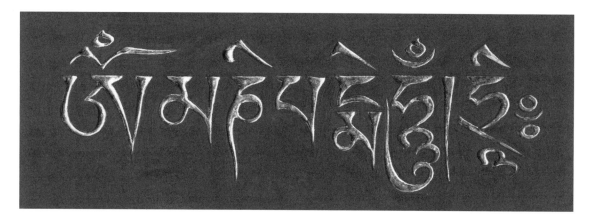

OM MANI PADME HUM (HRIH) mantra in raised gold letters.

The power of these mantras is said to be strong enough to change lives. My root lama, Kalu Rinpoche, always visited the zoos of each city he was in. He would stop and see all the animals and say OM MANI PEMÉ HUNG to each one, so that they would, by hearing the mantra, be reborn in the human realm in their next lifetime.

I had a life-changing experience when I first saw the same mantra printed on the cover of the Newark Museum's catalog in turquoise letters on orange paper. The year was 1968, and I hadn't had any previous Buddhist experience or teaching. But when I saw that mantra, something changed. There was a visual power that affected me immediately, and I realized that although I didn't even know what the meaning of this writing was, I felt deeply connected to it and felt moved to make copies of it and give it to others for their benefit. To this end I carved a large woodblock and printed hundreds of mantras and began to give them to everyone I met.

1. GETTING STARTED

No BOOK is the equivalent of studying and learning with a real teacher. The transference of knowledge through example, personal interaction, and even sometimes intuition that is possible from two persons interacting can only be pointed at in a book. On the other hand, for the student who has no teacher nearby and is willing to work, to experiment, and to give honest effort and time to mastering an art or a craft, a book can be a wonderful place to start. So if you have this book and are ready to begin, here are some simple suggestions.

Gather your materials from the list provided below. I recommend that you start with real ink and pens right from the beginning. Perhaps later you can work with flat-edge felt-tipped pens or other writing tools, but sometimes these are too easy to help with deeply learning the forms; we need to feel the liquid ink on the paper.

After you have gathered your materials, find a quiet place to practice.

Make friends with your pen.

Please don't forget to breathe; first inhale and then, as you exhale, feel the ink flowing out the pen onto the paper. This is very important, because if you hold your breath and tense your body, you will not achieve a good result.

Practice all the introductory pen strokes on pages 11–14, giving special effort to the ones that require a twist, or rotation, of the pen in your fingers. Practice first the vertical twist and then the horizontal twist. The accompanying photos on those pages should help you to see how the pen is manipulated for these strokes. When you have become successful with the introductory strokes, start the alphabet and practice each letter until you have achieved a good facsimile of the model in the book.

Spend some time every day practicing. Don't just dip in every two weeks or so. You need to practice regularly and for some time to develop ease and confidence in your letters.

After you have completed the alphabet and also mastered the stacked letters, you may want to try some of the mantras in the back of this book. It is very important to do the exercises in this book in the proper order; leaping ahead will only cause frustration, confusion, and obstacles.

CONTEMPLATIVE PRACTICE

Along with meditation, mantra chanting, and thangka painting, practicing Tibetan calligraphy can be considered a contemplative Dharma practice. When it is viewed in this way, it is very good to open the practice session with the refuge and bodhichitta prayers, then, at the end of the practice, you can dedicate the merit to all beings, so that the virtue of the practice will be shared by all. If your teacher has given you a particular form of the dedication prayer you can use that, or you can use the one on page 73.

Practicing like this, mindfully and keeping aware of the breath as one writes the letters, can be a source of inspiration to the student of calligraphy and can create some benefit for oneself and also for others.

MATERIALS

► pen holder (the wooden handle into which you insert the nib and which you grip while drawing or writing)
► pen nibs: Tape or Brause 2 ½ mm nib with reservoir, or Speedball C-2
► ink: Higgins Eternal (this is really the best choice for beginners as it is easy to wash out!)
► eye dropper to load ink into pen reservoir
► paper: pad of 11" x 17" gridded paper, 8 grids per inch
► fountain pen: Schaeffer's calligraphy fountain pen, medium nib

Optional Materials
► slanted easel (to allow writing at a better angle for better vision and straighter back)
► T square (if you're writing on nongridded paper, you can use this to create lines on the paper)
► drawing pencil, #2H is preferable
► vermillion Japanese liquid ink or your choice of gouache (opaque watercolor)
► larger nibs: Hiro #10 or #15

If your local art shop does not have the above items, most of them can be easily ordered online.

GLOSSARY OF IMPORTANT TERMS

Lantsa

The decorative letters derived from the Sanskrit *ranjana* script in the eleventh century. It is used in jewelry, sculpture, prayer wheels, and temple decorations. While we won't be learning lantsa in this book, it nonetheless is a beautiful alphabet worth exploring.

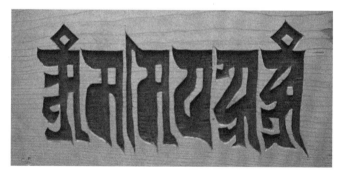

OM MANI PADME HUM mantra in lantsa carved in wood.

Pen Angle

The pen angle is the angle at which the pen is addressed to the paper; for our purposes, it should be forty-five degrees. Many alphabets, including the roman letters, are written with a forty-five or near-forty-five-degree angle. This is made possible by the use of a flat-edged pen, or a reed or bamboo pen such as those used by Tibetans. The benefit of writing at such a pen slant is the inherent beauty of the contrasting thick and thin elements of the characters, giving it a distinctive, calligraphic look.

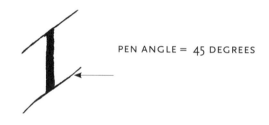

PEN ANGLE = 45 DEGREES

Pen Scale

The ratio of the height of the letter to the width of the pen nib. For example the uchen alphabet letters are seven pen widths high, assuming you are using the nibs mentioned in the section on materials. Some letter combinations may become taller than seven pen

widths, especially when letters are stacked on top of each other, or combined with vowel markers.

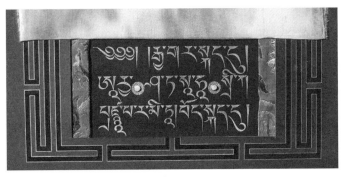

PEN SCALE = 7 USING 2½ MM NIB

Twist

The pen stroke used to create a properly tapering vertical stroke: thick at the top and diminishing to a hairline at the bottom. This is done by twisting or rotating the pen counterclockwise as it is moving down the page. To learn to do this, practice rolling the pen counterclockwise between the thumb and the middle finger. Notice how the thumb moves down toward the nib as the pen rotates and the tip of the pen is rotated to its vertical edge.

Uchen

The uchen script is the most prevalent form of Tibetan script, as it is the standard for printing. Its earliest use was in the transcribing of Buddhist scriptures from Sanskrit into Tibetan. The word literally means "with a head." It is comparable to the serif faces of roman type used for printing in the West and is the subject of this book.

Prajnaparamita text written in uchen.

Umé

Umé is a sort of sans-serif Tibetan script that has evolved many forms over time, from very formal and elegant scripts to Tibetan shorthand. It literally means "headless" because it does not include the header line employed by the uchen script; it also uses vertical lines rather than dots to separate syllables. A sample of one umé script called *drutsa* appears on the opposite page. A form of umé called *khyuyik* is the Tibetan cursive handwriting used for taking notes and writing informal letters.

"For as long as space exists and living beings endure, may I too remain to dispel the misery of the world."
—Shantideva
Umé lettering by Tashi Mannox.

2. THE FUNDAMENTAL PEN STROKES

BEFORE BEGINNING to practice the alphabet, it is important to understand and practice a few fundamental pen strokes. Some of these will come quite easily, but two of them will take a little effort to master: the vertical twist stroke and the horizontal twist stroke. Make sure you are comfortable with these basic strokes before attempting any of the letters of the alphabet.

All characters in this book will have a pen scale of seven and a pen angle of forty-five degrees unless otherwise noted.

THE HORIZONTAL STROKE

The pen is held at a forty-five-degree angle to the paper.

THE VERTICAL TWIST STROKE

The vertical twist stroke begins with the pen held at a forty-five-degree angle to the paper. As the stroke moves down the paper, the pen is rotated counterclockwise between the fingers, creating a tapered shape. Practice doing this until you manage a smooth flow of ink and a smooth even taper from top to bottom.

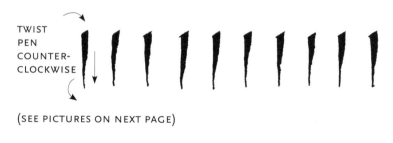

TWIST
PEN
COUNTER-
CLOCKWISE

(SEE PICTURES ON NEXT PAGE)

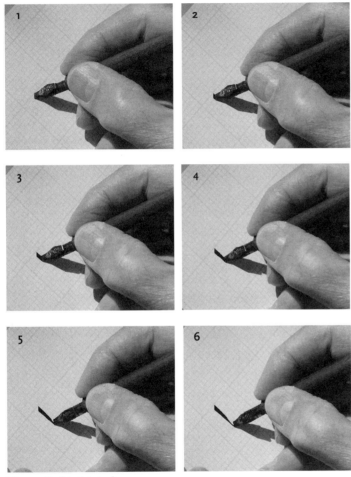

The vertical twist stroke.

THE DOWNWARD DIAGONAL TWIST

The downward diagonal twist rotates counterclockwise as the pen is moving toward the lower righthand corner of the page.

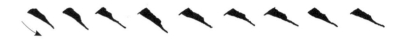

THE UPWARD DIAGONAL

The upward diagonal, so called because of its slight but important upward movement, rotates clockwise to produce a thin ending.

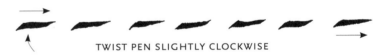

TWIST PEN SLIGHTLY CLOCKWISE

THE LOWER HALF OF A CIRCLE

No twist or pen manipulation.

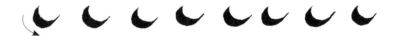

THE UPPER HALF OF A CIRCLE

No twist or pen manipulation.

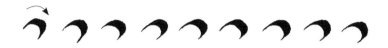

THE FULL CIRCLE

This stroke joins the previous two strokes.

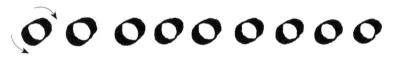

THE HORIZONTAL TWIST STROKE

This stroke starts with the pen at a forty-five-degree angle to the paper and then goes up and makes a curved horizontal, at the same time as it is rotated by the fingers counterclockwise. The pen finishes on the left tip of the pen making a hairline. This shape looks like an eyebrow. Practice doing this stroke until it is smooth and flowing.

TWIST PEN COUNTERCLOCKWISE

(SEE PICTURES ON NEXT PAGE)

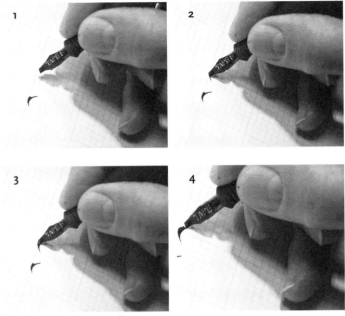

The horizontal twist stroke.

THE CURLING UPWARD TWIST

This final stroke starts at the bottom of the figure and moves down to the right and then around to the left and then up toward the upper lefthand corner of the page, using the counterclockwise twist as it ends in a fine hair line.

ᵁᵁᵁᵁᵁᵁ ᵁᵁᵁᵁ

TWIST PEN SLIGHTLY COUNTERCLOCKWISE

3. THE ALPHABET

BEFORE LEARNING the alphabet, it is helpful to know something about how Tibetan is romanized.

The standard system for transcribing Tibetan in roman letters in the West is called Wylie, named after the late scholar at the University of Washington who devised it. Wylie is great for seeing how words are spelled, but due to the prevalence of so many silent consonants and combinations in Tibetan, it is not so good for showing how a word is pronounced. Not everyone agrees, however, on the best system for phonetic romanization—there are many in use and none is predominant.

This book uses the system of the *Library of Tibetan Classics*, which indicates the presence of aspiration with the addition of an h after a letter. This means that TH and PH are not pronounced as in English but are instead spoken as a normal *t* or *p* but with an extra force of air. *Thangka* is therefore pronounced "tongka."

The *Library of Tibetan Classics* system also uses umlauts for *ü* and *ö* to show vowel modifications analogous to their use in German. And an accent is used above an *e* to indicate that it should be spoken and not silent. Thus *chösé* would be pronounced "chusay," and *shé* should be pronounced "shay."

If you learn to read uchen, then reading Wylie is easy, since it simply transcribes the Tibetan letters. But for others, many Wylie spellings are simply unfathomable, and that is why phonetic spellings are necessary. In this book, the names of letters are given in Wylie, but letter combinations and Tibetan words are rendered phonetically. Sanskrit words are rendered with standard Sanskrit phonetics.

1: KA

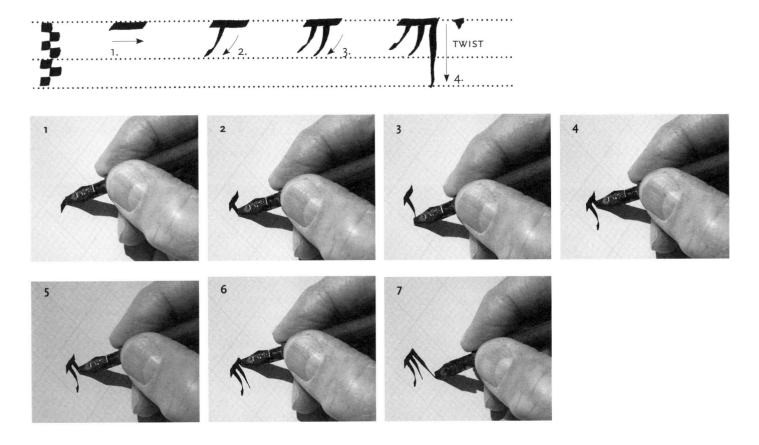

2: KHA

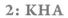

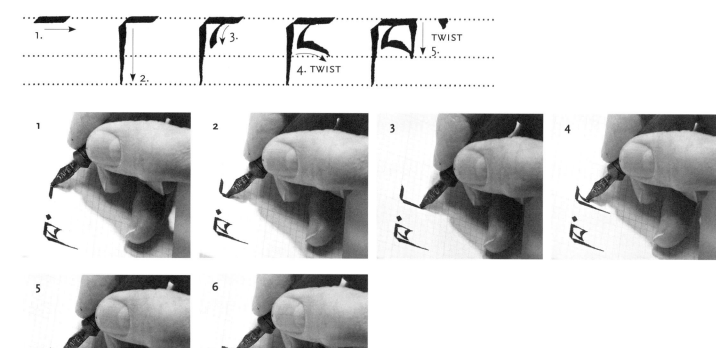

3: GA

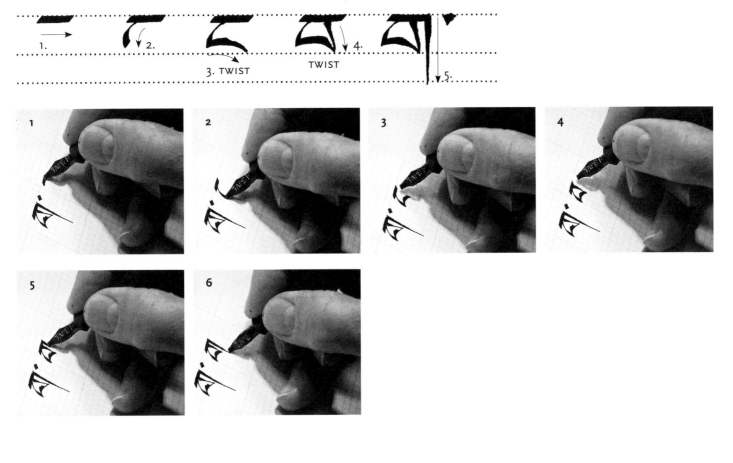

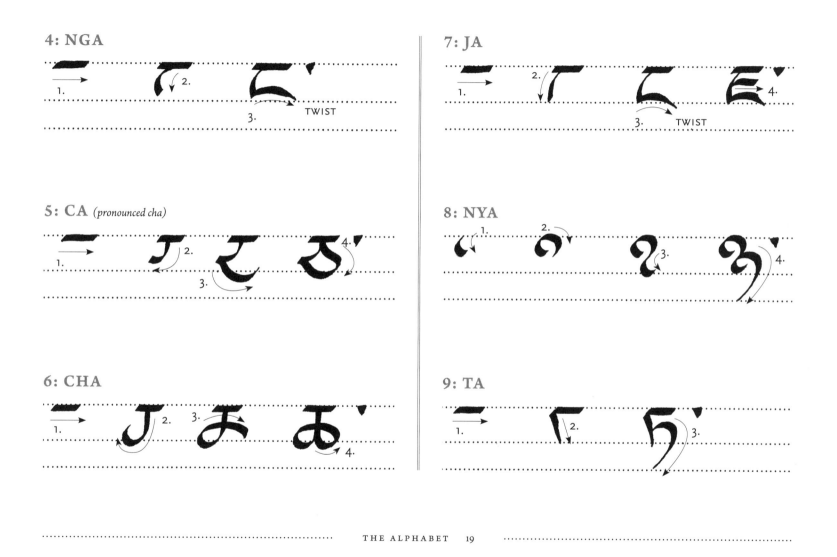

4: NGA

5: CA *(pronounced cha)*

6: CHA

7: JA

8: NYA

9: TA

TWIST

TWIST

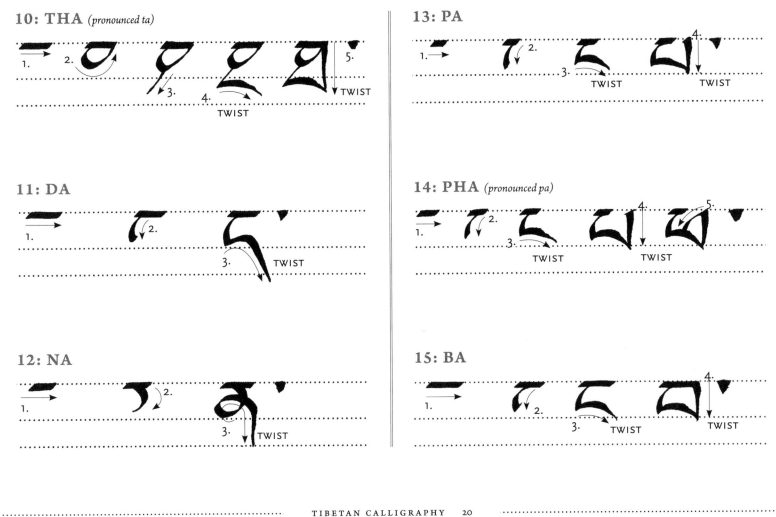

10: THA *(pronounced ta)*

1. → 2. 3. 4. TWIST 5. ▼ TWIST

11: DA

1. → 2. 3. TWIST

12: NA

1. → 2. 3. TWIST

13: PA

1. → 2. 3. TWIST 4. TWIST

14: PHA *(pronounced pa)*

1. → 2. 3. TWIST 4. TWIST 5.

15: BA

1. → 2. 3. TWIST 4. TWIST

16: MA

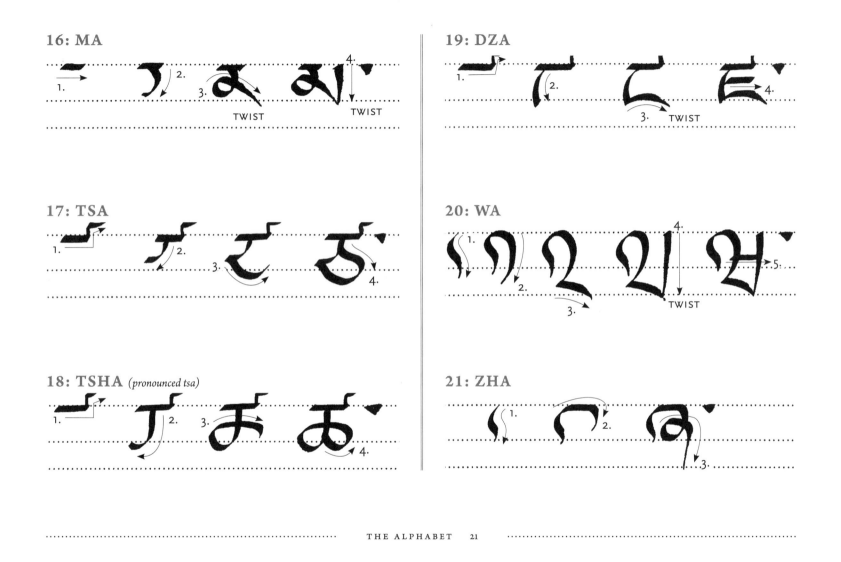

17: TSA

18: TSHA *(pronounced tsa)*

19: DZA

20: WA

21: ZHA

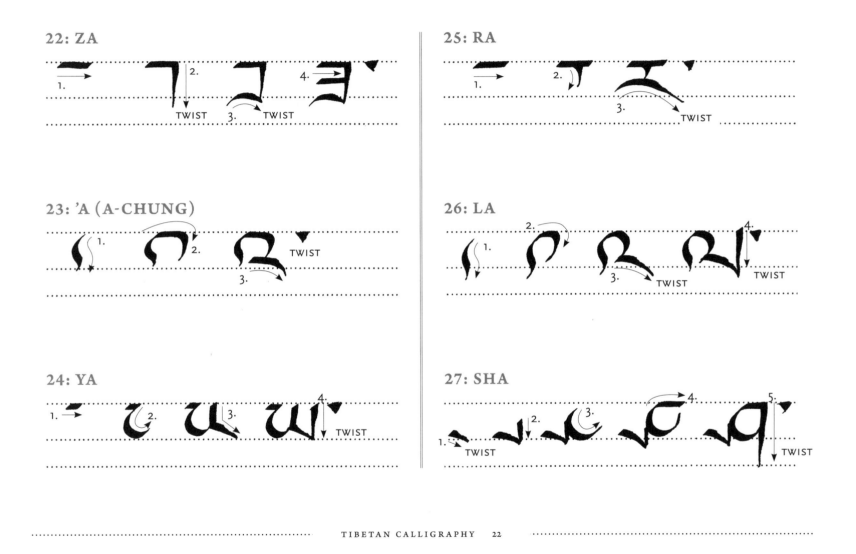

22: ZA

1. → TWIST 2. TWIST 3. TWIST 4. →

23: 'A (A-CHUNG)

1. 2. TWIST 3.

24: YA

1. → 2. 3. 4. TWIST

25: RA

1. → 2. 3. TWIST

26: LA

1. 2. 3. TWIST 4. TWIST

27: SHA

1. TWIST 2. 3. 4. 5. TWIST

28: SA

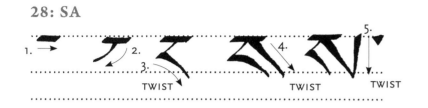

1. → 2. 3. 4. 5.

TWIST TWIST TWIST

29: HA

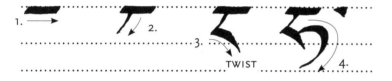

1. → 2. 3. 4.

TWIST

30: A

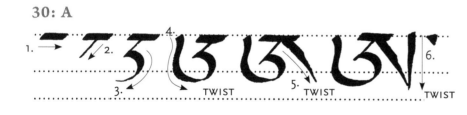

1. → 2. 3. 4. 5. 6.

TWIST TWIST TWIST

4. VOWEL MARKERS

TIBETAN IS a phonetic alphabet with thirty consonants and five vowels. Each letter in the alphabet has the assigned vowel of "A," which is pronounced like the vowel in "cup." To get the sound of the other vowels—E, I, O, U—Tibetan uses the vowel markers below. With the exception of the *shapkyu*, which is written below the letter, the vowel markers are written just above the letter that they affect.

Please make sure you are confident with the alphabet before you begin practicing adding vowel markers.

GIGU

Gigu, pronounced "ghi-goo," is the vowel marker for the sound of "I," which sounds like "ee" as in "seek," and is written above the letter modified.

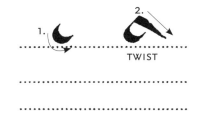

TWIST

DRENGBU

Drengbu is the vowel marker for the sound of "E," which sounds like "a" as in "mate" and is written above the letter modified.

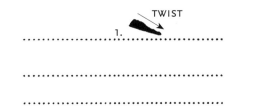

NARO

Naro is the vowel marker for the sound of "O," which sounds like the "o" in "Rome" and is written above the letter modified.

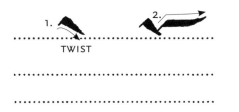

SHAPKYU

Shapkyu is the vowel marker for sound of "U," which sounds like the "oo" in "boot," and is written below the letter modified.

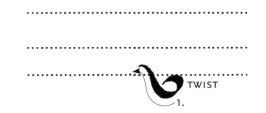

For an example of the use of vowel markers, you can examine the mantra OM MANI PADME HUM on page 54: the naro is visible in the first letter, turning the A to O. Over the NA we find the gigu, turning the NA to NI. Over the PADMA we find the drengbu, turning it to PADME. Finally, under the HA we find the shapkyu, turning the HA to HU.

Sometimes you will see a vowel marker doubled to reflect the long Sanskrit vowels. Now we will practice adding these markers to the letter KA.

KA

The letter KA, unadorned by vowel markers.

KI

The letter KA, with a gigu.

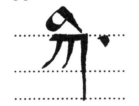

KU

The letter KA, with a shapkyu.

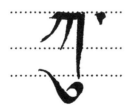

KE

The letter KA, with a drengbu.

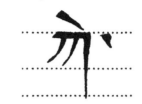

KO

The letter KA, with a naro.

5. STACKED LETTERS

IN THE TIBETAN LANGUAGE, many words are spelled with combinations of consonants that are "stacked" vertically on top of each other. Sometimes both letters are complete, and sometimes one is only partial. Sometimes these stacked letters indicate a change in the pronunciation of a syllable. Sometimes one of the characters is not pronounced at all, but the spelling change indicates a change in the meaning of the word. One of the keys to learning to pronounce Tibetan words is to study the following charts of the stacked letters and memorize which letters are silent and which ones change radically to another sound.

SUBJOINED LETTER COMBINATIONS

In some letter combinations, one of the letters is referred to as *subjoined*, or occasionally *subscribed*: only part of the letter is drawn and it is added below another. We'll practice this first with the following seven subjoined letter combinations that all use the subjoined letter YA. YA, in these combinations, is not specifically pronounced but does affect the pronunciation of the syllable. When YA is serving this function, it is referred to as *yatak*. So in the first example, we are combining the letter KA with the subjoined and unpronounced letter YA (or *yatak*) to create a letter combination that is pronounced as KYA.

YATAK

Subjoined YA; Seven Combinations

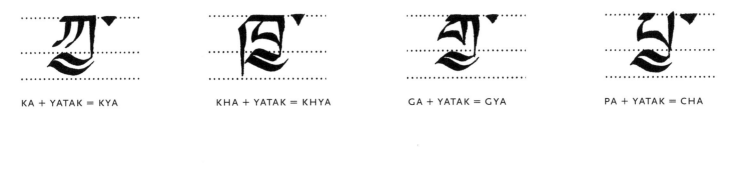

KA + YATAK = KYA

KHA + YATAK = KHYA

GA + YATAK = GYA

PA + YATAK = CHA

PHA + YATAK = CHA

BA + YATAK = JA

MA + YATAK = NYA

RATAK

Subjoined RA; Fourteen Combinations

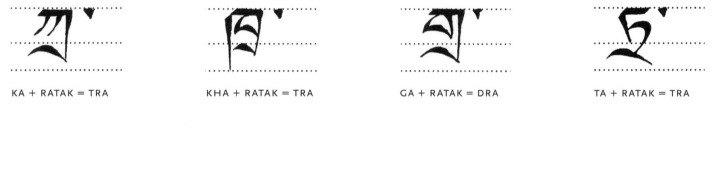

KA + RATAK = TRA

KHA + RATAK = TRA

GA + RATAK = DRA

TA + RATAK = TRA

THA + RATAK = TRA

DA + RATAK = DRA

NA + RATAK = NA

PA + RATAK = TRA

PHA + RATAK = TRA BA + RATAK = DRA MA + RATAK = MA SHA + RATAK = SHRA
(Used for Sanskrit transliteration)

SA + RATAK = SA HA + RATAK = HRA

LATAK

Subjoined LA; Six Combinations

Please note that, while most of the results of the *latak* combinations are roughly pronounced LA, there are actually subtle differences in enunciation between them.

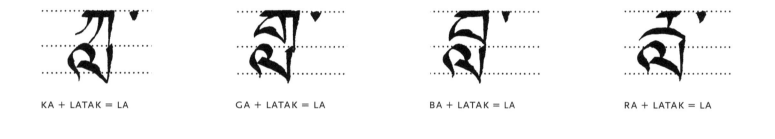

KA + LATAK = LA GA + LATAK = LA BA + LATAK = LA RA + LATAK = LA

 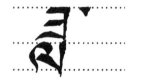

SA + LATAK = LA ZA + LATAK = DA

HATAK

Subjoined HA; Five Combinations

Except for LHA, these are primarily used to transliterate aspirated Sanskrit letters not present in Tibetan.

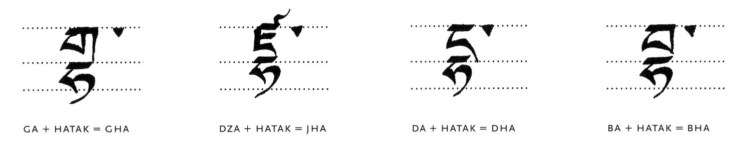

GA + HATAK = GHA DZA + HATAK = JHA DA + HATAK = DHA BA + HATAK = BHA

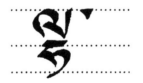

LA + HATAK = LHA

WAZURS

Subjoined WA; Sixteen Combinations

Letter combinations comprised of a partial WA affixed to an entire other letter are called *wazurs*. A wazur does not typically change the pronunciation of the root letter but is a simple spelling change used to indicate a different meaning for the word. For instance, ZA can mean "to eat," but with a wazur it refers to a nettle.

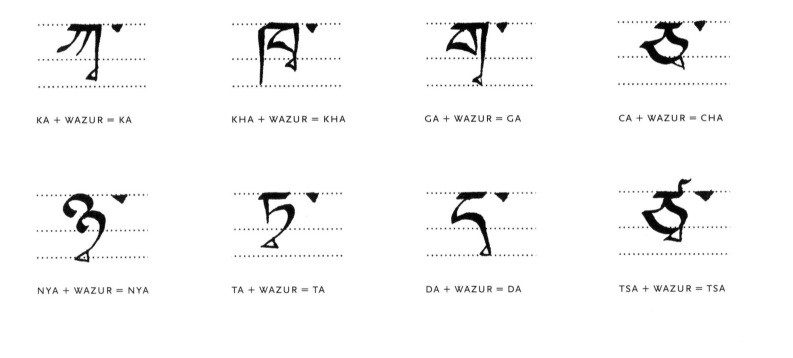

KA + WAZUR = KA

KHA + WAZUR = KHA

GA + WAZUR = GA

CA + WAZUR = CHA

NYA + WAZUR = NYA

TA + WAZUR = TA

DA + WAZUR = DA

TSA + WAZUR = TSA

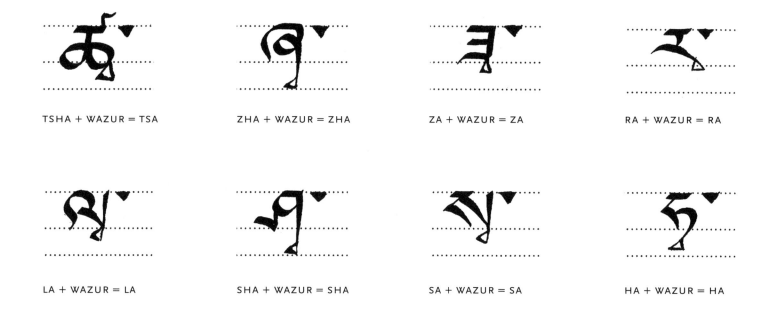

TSHA + WAZUR = TSA

ZHA + WAZUR = ZHA

ZA + WAZUR = ZA

RA + WAZUR = RA

LA + WAZUR = LA

SHA + WAZUR = SHA

SA + WAZUR = SA

HA + WAZUR = HA

A-CHUNG

Subjoined 'A

A-chung in Tibetan means "little A." When it is subjoined to other letters, it has the effect of lengthening the sound of the vowel. An example of this is in the seed syllable group OM AH HUM on page 52, in which the a-chung is attached below the big A. This changes the sound of the A from the vowel sound in "but" to the "a" sound in "father."

SUPERJOINED LETTER COMBINATIONS

In superjoined letter combinations, sometimes known as superscribed combinations, a whole or partial letter is drawn on top of a whole root letter. Again, a superjoined letter does not always affect the pronunciation of the root letter, but the spelling change indicates that the meaning of the word has changed. We will begin this exercise with twelve examples of the letter RA (which is referred to as RAGO when super-joined, though it is not pronounced that way when verbally spelled) combined with a root letter, which is indicated by the suffix -TAK. So in the first example we are drawing the letter RA above the letter KA. Notice that in all the variants the combination is pronounced the same as the root letter and thus the RAGO is typically silent, though it sometimes gets pronounced in the middle of words, as with *dorje*.

RAGO

Superjoined RA; Twelve Combinations

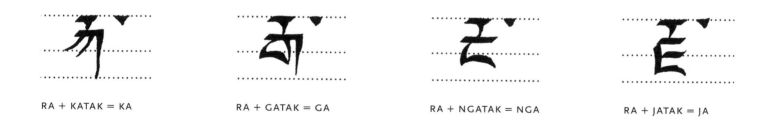

RA + KATAK = KA RA + GATAK = GA RA + NGATAK = NGA RA + JATAK = JA

Please notice in this first combination, the RA
is not abbreviated; the whole letter is written.

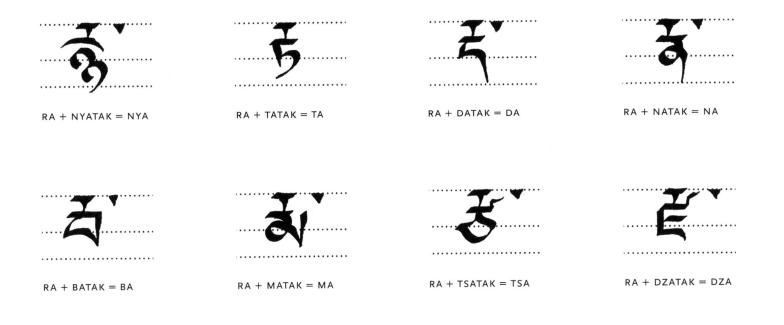

RA + NYATAK = NYA

RA + TATAK = TA

RA + DATAK = DA

RA + NATAK = NA

RA + BATAK = BA

RA + MATAK = MA

RA + TSATAK = TSA

RA + DZATAK = DZA

LAGO

Superjoined LA; Ten Combinations

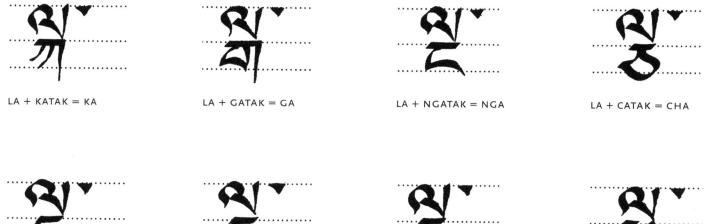

LA + KATAK = KA

LA + GATAK = GA

LA + NGATAK = NGA

LA + CATAK = CHA

LA + JATAK = JA

LA + TATAK = TA

LA + DATAK = DA

LA + PATAK = PA

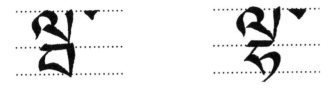

LA + BATAK = BA

LA + HATAK = LHA

SAGO

Superjoined SA; Eleven Combinations

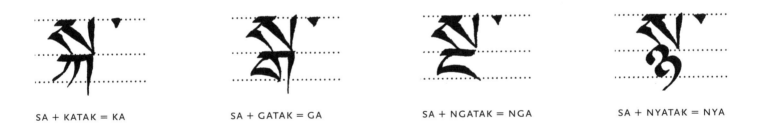

SA + KATAK = KA

SA + GATAK = GA

SA + NGATAK = NGA

SA + NYATAK = NYA

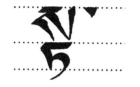

SA + TATAK = TA

SA + DATAK = DA

SA + NATAK = NA

SA + PATAK = PA

SA + BATAK = BA

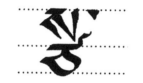

SA + MATAK = MA

SA + TSATAK = TSA

6. THE SIX REVERSED LETTERS

THE SIX REVERSED LETTERS are Tibetan letters that have been reversed to indicate Sanskrit letters that don't exist in Tibetan. When verbally spelled, this reversal is indicated as LO, though there is no extra penstroke or other character. The reversed letters are pronounced with the tongue farther back on the roof of the mouth than the nonreversed forms.

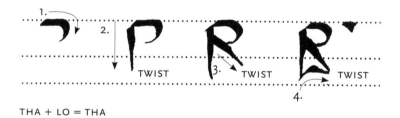

THA + LO = THA

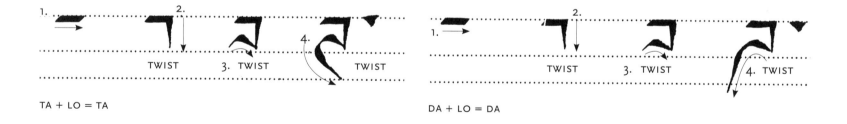

TA + LO = TA

DA + LO = DA

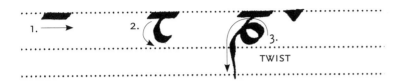

1. → 2. 3. TWIST

NA + LO = NA

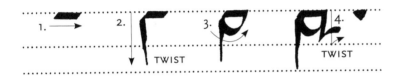

1. → 2. TWIST 3. 4. TWIST

SHA + LO = SHA

In the final exercise for this section, we stack the letter KA with a reversed SHA to create the new character KSHA. This is also used for Sanskrit, as with the buddha name Akshobhya.

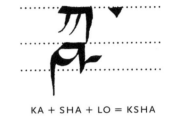

KA + SHA + LO = KSHA

7. PUNCTUATION

TSEK

TIBETAN WORDS are made up of syllables of consonants along with their vowel markers. These syllables are separated by a dot called a *tsek*.

SHÉ

At the end of a line or a sentence, there is a vertical line called a *shé*.

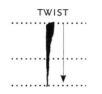

NAMCHÉ

A character found in seed syllables, mantras, and sometimes as a special punctuation in *terma* texts hidden by Padmasambhava and Yeshé Tsogyal is known as the *namché*. The namché comes from Sanskrit texts, where it is called a *visarga*. It indicates a kind of aspiration that extends the length of the vowel. It was copied by the Tibetans when they created mantras and seed syllables in Tibetan.

The namché can be recognized by two circles resting one above the other.

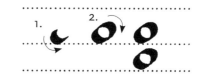

YIKGO

At the beginning of a page, and sometimes at the beginning of a mantra, there is a fancy symbol called a *yikgo*.

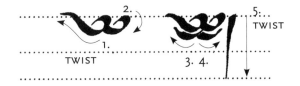

JESU NGARO

A single circle called a *jesu ngaro* (Sanskrit *anusvara*) is sometimes found at the top of a letter in a Sanskrit word or seed syllable, indicating a nasalization with the sound of *m* or *ng* at the end of the syllable. This marker usually is a circle but sometimes is written decoratively as a flame or as a *thiklé*, a drop (Sanskrit *bindu*). In the lantsa alphabet, it appears as a small diamond.

You can see many of these in use in the Vajrasattva mantra on pages 68–69. An excellent example of the namché is in the seed syllable AH on page 49, and you can see the jesu ngaro in the seed syllables HUM, OM, and BHRUM on page 50. You will notice that the thiklé will sometimes include a crescent underneath, but this is largely ornamental and does not affect pronunciation.

8. NUMERALS

CHIK: *one* **NYI:** *two* **SUM:** *three*

ZHI: *four* **NGA:** *five* **DRUK:** *six*

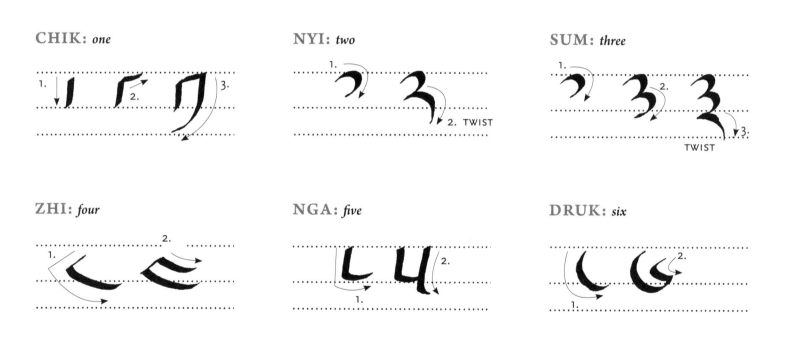

DUN: *seven*

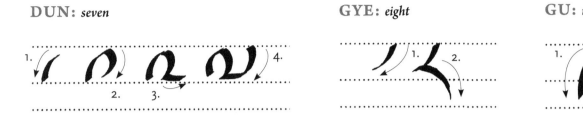

GYE: *eight*

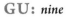

GU: *nine*

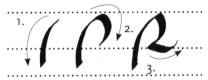

LEKOR: *zero*

As you can see in the next calligraphy, creating larger numbers in Tibetan is the same as with arabic numerals; the number 10 is simply the number 1 in front of the number 0.

CHU: *ten*

9. SEED SYLLABLES

IBETAN SEED SYLLABLES do not have meanings that can be put into words but are used as symbols, both visual and auditory, to invoke a specific focus: a deity, for instance, or the essence of the chakras of "body, speech, and mind," or the germination point of a mantra. They are an important part of Tibetan Buddhist meditation practice. It is out of these seed syllables that the image or visualization of the deity arises or becomes manifest in the mind of the practitioner.

As you draw these seed syllables (and the mantras in the next chapter), please be aware that you are working with powerful, ancient tantric symbols. Therefore, bring that spirit of meditative concentration into your calligraphy and create letters that will match that intention. As well, be aware that these characters are a good deal more complex than the more basic letters and numbers we've done so far; make sure you're comfortable with those before you attempt these.

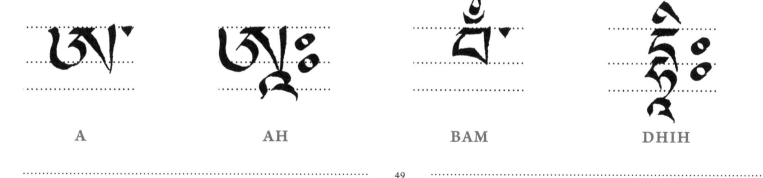

A AH BAM DHIH

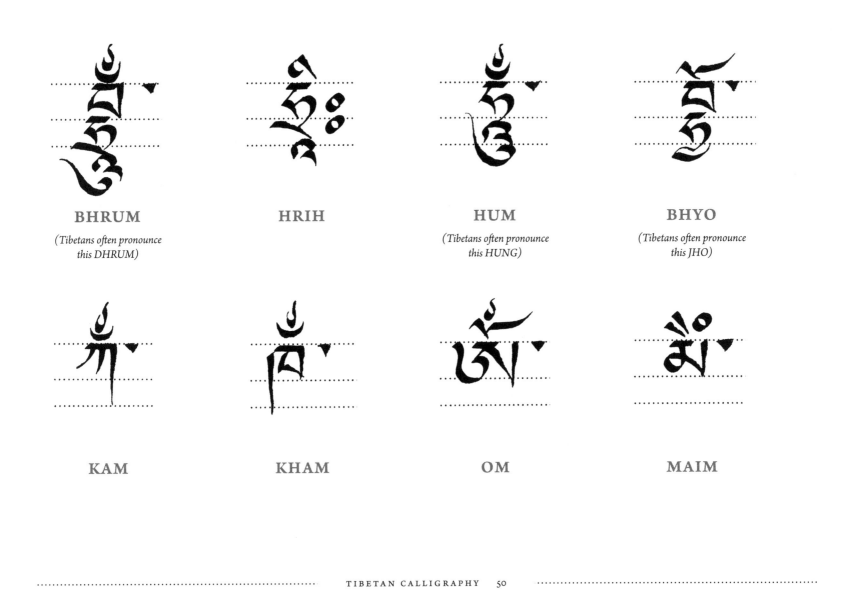

BHRUM

(Tibetans often pronounce this DHRUM)

HRIH

HUM

(Tibetans often pronounce this HUNG)

BHYO

(Tibetans often pronounce this JHO)

KAM

KHAM

OM

MAIM

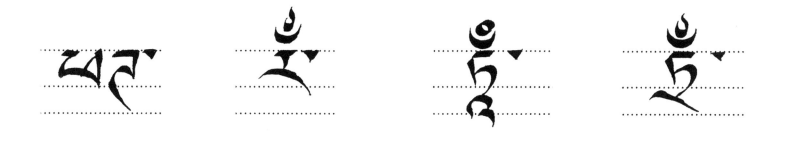

PHAT

(Tibetans pronounce this PAY)

RAM

TAM

TRAM

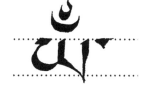

YAM

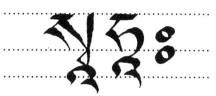

SVA HA

(Tibetans often pronunce this SO HA)

The seed syllables OM, AH, and HUM are often seen grouped together vertically to show their position vis-à-vis the human body: the OM is at the third-eye center, the AH is at the throat center, and the HUM is at the heart center. Thus, OM signifies body, AH signifies speech, and HUM signifies the mind/heart. These three sacred symbols are also written vertically on the back of thangkas in exactly the same position. When written vertically, there are no tseks. The tsek is usually used only in horizontal writing.

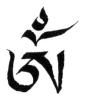

10. MANTRAS

MANTRAS, LIKE SEED SYLLABLES, are not meant to be translated. They almost always have their origins in the tantric Buddhist tradition of India and are Tibetan transcriptions of the original Sanskrit syllables. They function as potent, even magical sounds. Since they are almost always connected to a specific deity, they may be considered to be an aid to invoking and visualizing the specific deity. Seed syllables can function as the essence of the mantra, or of the deity itself.

Try using your smaller fountain pen and begin writing the following mantras. At this point you will need to begin to become aware of not just the letter forms but also the arrangement of the whole page.

You are creating a composition, and you will need to make design decisions: how wide are the margins, how close are the letters to each other, how much space is between the lines? If you choose to do some projects such as texts or mantras on a large scale, you may have decisions to make regarding color, the size of letters, and the kind of paper or cardboard or other materials you will write on.

Some examples of completed projects are included here, not necessarily for you to copy, but as a guide and inspiration for your own creativity. Please also note that we have written out the Sanskrit pronunciation, which is not always how a Tibetan speaker would say these mantras. If you are given a mantra practice from a teacher, you generally follow his or her pronunciation.

AVALOKITESHVARA

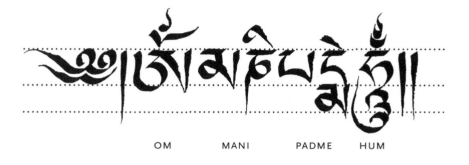

OM MANI PADME HUM

VAJRAYOGINI

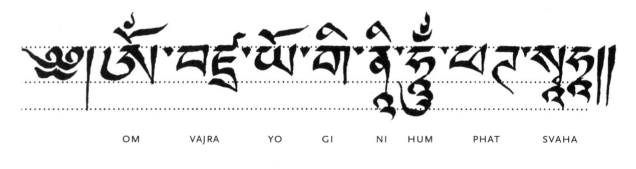

OM VAJRA YO GI NI HUM PHAT SVAHA

AMOGHASIDDHI

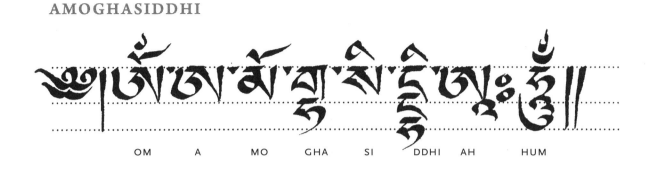

OM A MO GHA SI DDHI AH HUM

MAITREYA

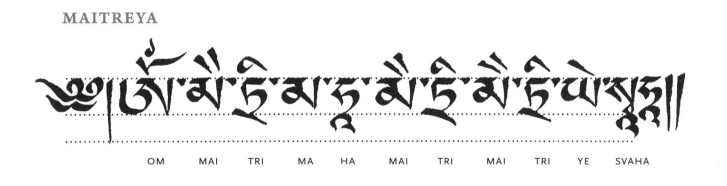

OM MAI TRI MA HA MAI TRI MAI TRI YE SVAHA

PRAJNAPARAMITA

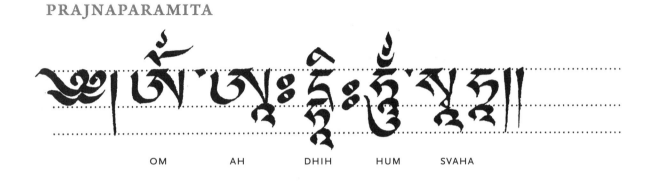

OM AH DHIH HUM SVAHA

VAIROCHANA

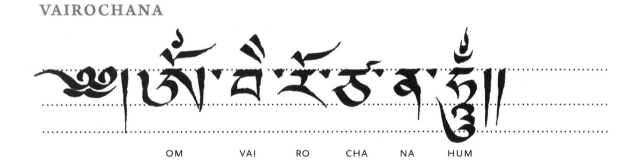

OM VAI RO CHA NA HUM

AKSHOBHYA

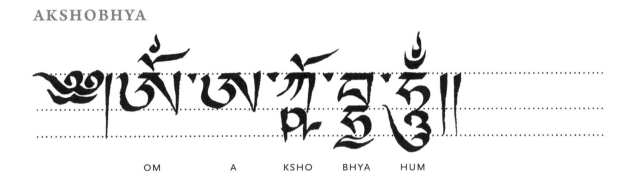

OM A KSHO BHYA HUM

RATNASAMBHAVA

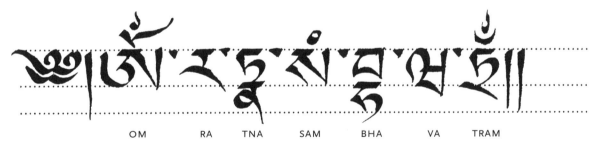

OM RA TNA SAM BHA VA TRAM

AMITABHA

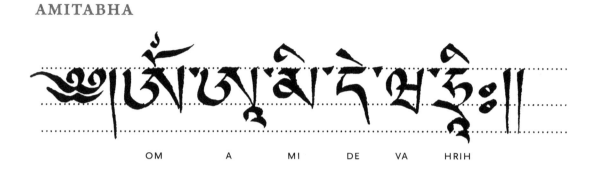

OM A MI DE VA HRIH

HAYAGRIVA

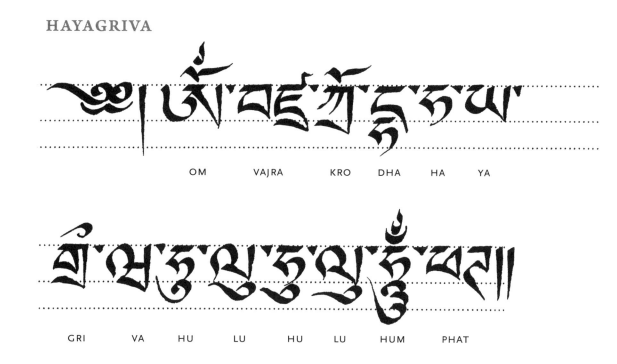

OM VAJRA KRO DHA HA YA

GRI VA HU LU HU LU HUM PHAT

WHITE TARA

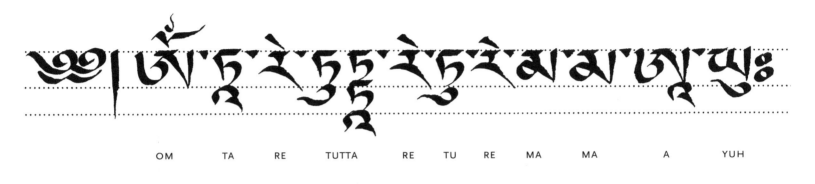

OM · TA · RE · TUTTA · RE · TU · RE · MA · MA · A · YUH

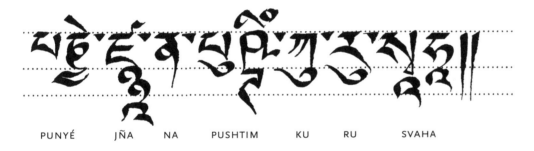

PUNYÉ · JÑA · NA · PUSHTIM · KU · RU · SVAHA

KARMAPA

This is the only mantra here composed of Tibetan rather than Sanskrit words.

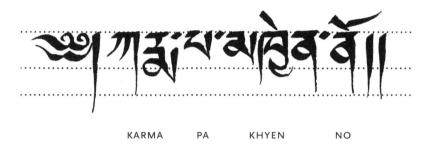

KARMA PA KHYEN NO

SHORT VAJRASATTVA

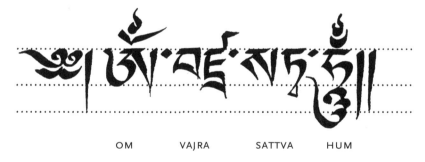

OM VAJRA SATTVA HUM

PADMASAMBHAVA

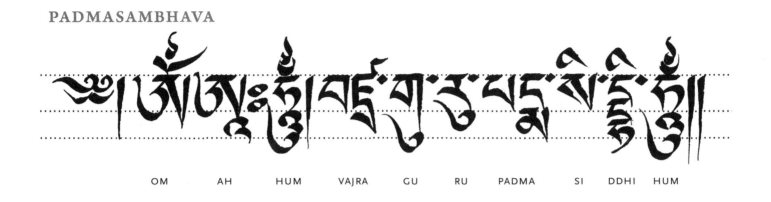

OM AH HUM VAJRA GU RU PADMA SI DDHI HUM

ESSENCE OF THE HEART SUTRA

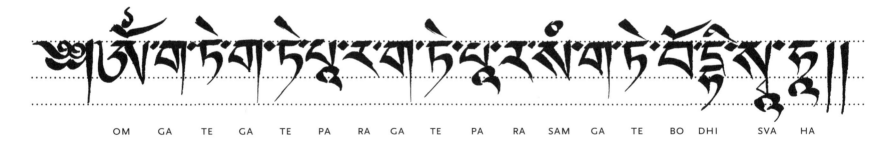

OM GA TE GA TE PA RA GA TE PA RA SAM GA TE BO DHI SVA HA

SHAKYAMUNI BUDDHA

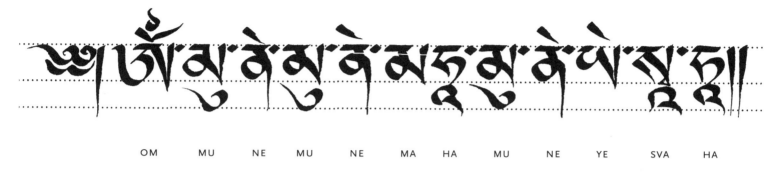

OM MU NE MU NE MA HA MU NE YE SVA HA

MANJUSHRI

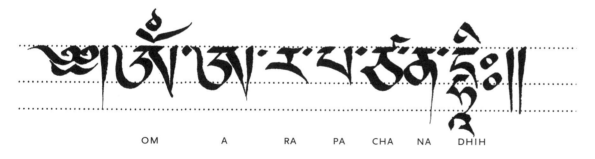

OM A RA PA CHA NA DHIH

GREEN TARA

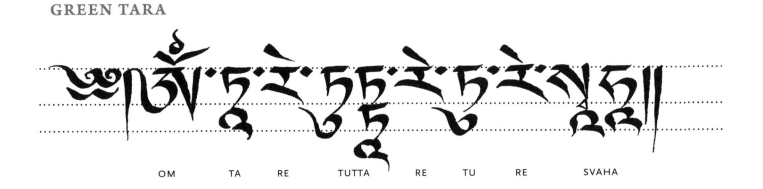

OM TA RE TUTTA RE TU RE SVAHA

MEDICINE BUDDHA (BHAISHAJYAGURU)

Tibetan pronunciation of this mantra is markedly different from the Sanskrit. Tibetans would say this more like TEYATHA OM BEKANZÉ BEKANZÉ MAHA BEKANZÉ RADZA SAMUGATÉ SOHA.

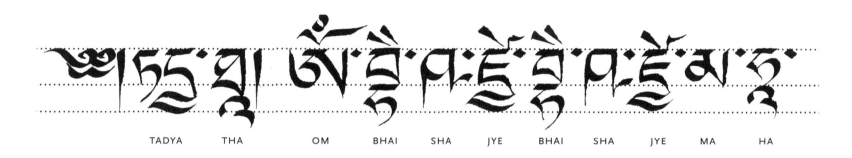

TADYA THA OM BHAI SHA JYE BHAI SHA JYE MA HA

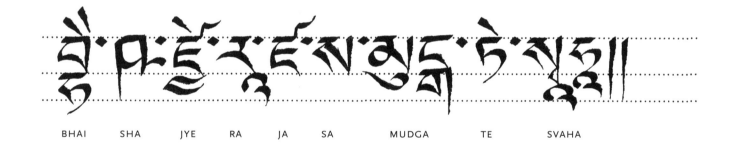

BHAI SHA JYE RA JA SA MUDGA TE SVAHA

VAJRASATTVA

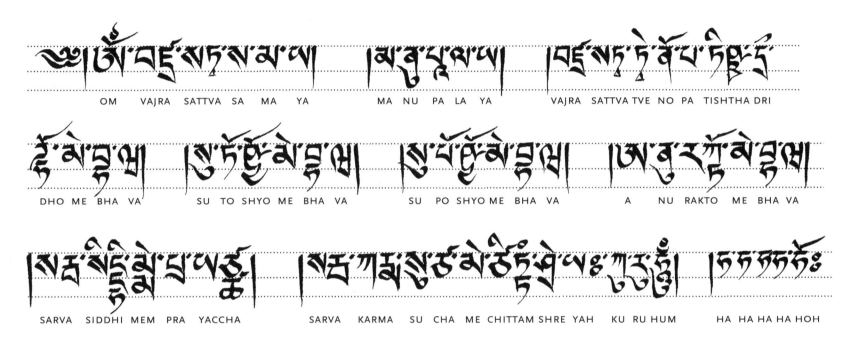

OM VAJRA SATTVA SA MA YA MA NU PA LA YA VAJRA SATTVA TVE NO PA TISHTHA DRI

DHO ME BHA VA SU TO SHYO ME BHA VA SU PO SHYO ME BHA VA A NU RAKTO ME BHA VA

SARVA SIDDHI MEM PRA YACCHA SARVA KARMA SU CHA ME CHITTAM SHRE YAH KU RU HUM HA HA HA HA HOH

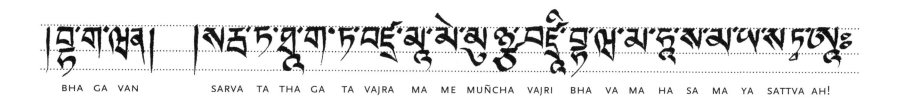

BHA GA VAN SARVA TA THA GA TA VAJRA MA ME MUÑCHA VAJRI BHA VA MA HA SA MA YA SATTVA AH!

Om. By the vow of Vajrasattva, keeping guard, thou Vajrasattva, stay near, steady me, satisfy me, enrich me, be loving toward me.

Bestow on me all perfections. In all deeds, also, make my mind virtuous. The four joys. Blessed ones.

All the thus-gone, diamond one, do not abandon me. Make me adamantine, thou being of the great vow.

11. PRAYERS

MANTRAS AND PRAYERS have some similarities and some differences. The similarities are that they both are practiced with a mind of faith and devotion, and the merit from both is offered to all beings. The difference is that mantras are used for the invocation of a specific deity or enlightened being (a buddha, a bodhisattva, or a great teacher like Padmasambhava or Milarepa) and that the literal meaning of the mantra may be elusive.

Prayers, on the other hand, may be of many kinds: prayers of offering for food, prayers for the long life of a teacher, aspiration prayers for one's practice and for the benefit of all beings, and prayers for those who are suffering, both mentally and physically. Some are prayers of dedication of merit, so that whatever good is accomplished in Dharma practice is dedicated to the benefit of all beings rather than oneself alone. And unlike mantras, prayers are suitable to be translated.

The prayers on the following pages are just a few examples for you to practice.

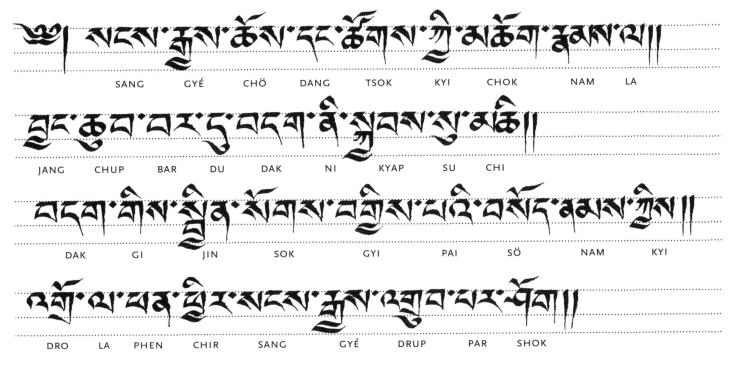

SANG GYÉ CHÖ DANG TSOK KYI CHOK NAM LA

JANG CHUP BAR DU DAK NI KYAP SU CHI

DAK GI JIN SOK GYI PAI SÖ NAM KYI

DRO LA PHEN CHIR SANG GYÉ DRUP PAR SHOK

In the Buddha, the Dharma, and the Sangha,
I take refuge until I reach enlightenment.
By the merit from practicing generosity and other perfections,
may I achieve buddhahood for the benefit of all beings.

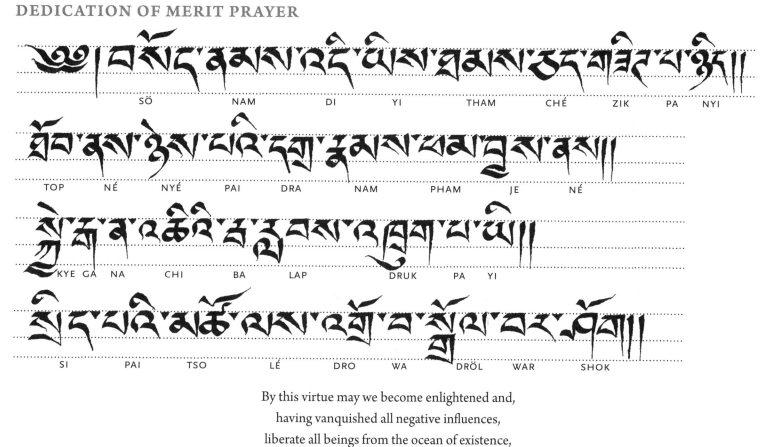

SÖ NAM DI YI THAM CHÉ ZIK PA NYI

TOP NÉ NYÉ PAI DRA NAM PHAM JE NÉ

KYE GA NA CHI BA LAP DRUK PA YI

SI PAI TSO LÉ DRO WA DRÖL WAR SHOK

By this virtue may we become enlightened and,
having vanquished all negative influences,
liberate all beings from the ocean of existence,
turbid with the waves of birth, old age, sickness, and death.

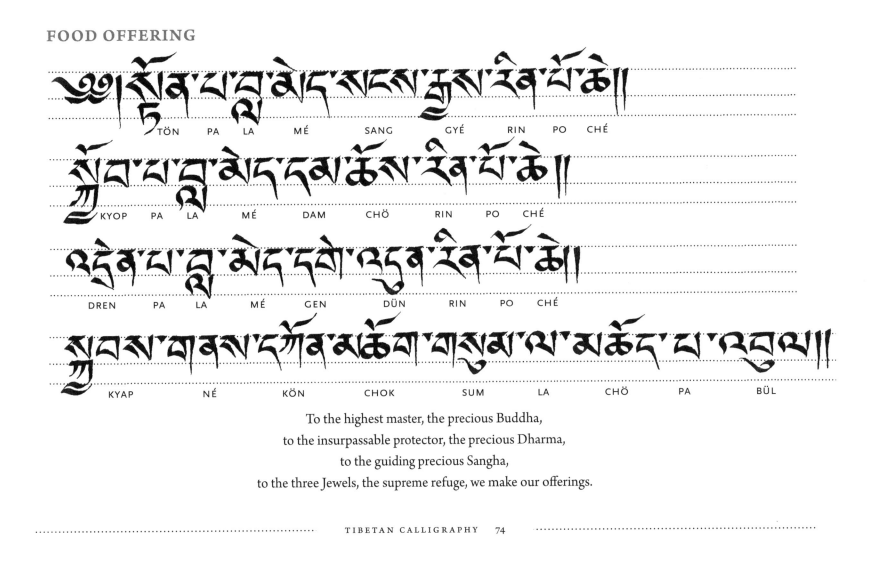

ༀ། སྟོན་པ་བླ་མེད་སངས་རྒྱས་རིན་པོ་ཆེ།།

TÖN PA LA MÉ SANG GYÉ RIN PO CHÉ

སྐྱོབ་པ་བླ་མེད་དམ་ཆོས་རིན་པོ་ཆེ།།

KYOP PA LA MÉ DAM CHÖ RIN PO CHÉ

འདྲེན་པ་བླ་མེད་དགེ་འདུན་རིན་པོ་ཆེ།།

DREN PA LA MÉ GEN DÜN RIN PO CHÉ

སྐྱབས་གནས་དཀོན་མཆོག་གསུམ་ལ་མཆོད་པ་འབུལ།།

KYAP NÉ KÖN CHOK SUM LA CHÖ PA BÜL

To the highest master, the precious Buddha,
to the insurpassable protector, the precious Dharma,
to the guiding precious Sangha,
to the three Jewels, the supreme refuge, we make our offerings.

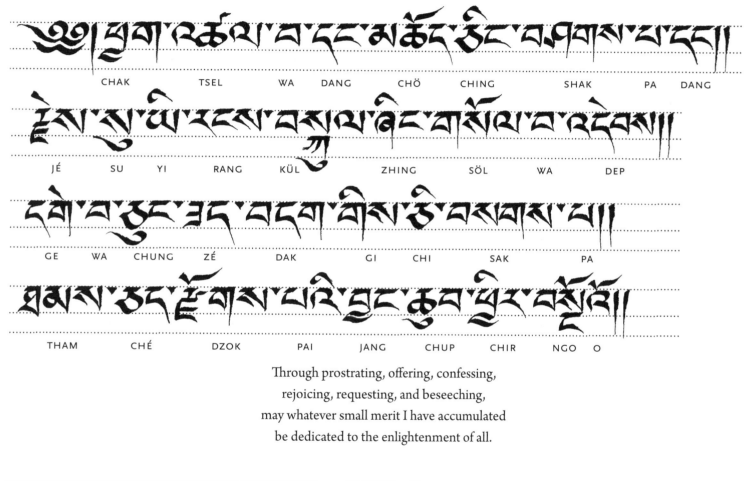

CHAK TSEL WA DANG CHÖ CHING SHAK PA DANG

JÉ SU YI RANG KÜL ZHING SÖL WA DEP

GE WA CHUNG ZÉ DAK GI CHI SAK PA

THAM CHÉ DZOK PAI JANG CHUP CHIR NGO O

Through prostrating, offering, confessing,
rejoicing, requesting, and beseeching,
may whatever small merit I have accumulated
be dedicated to the enlightenment of all.

THE FOUR IMMEASURABLES

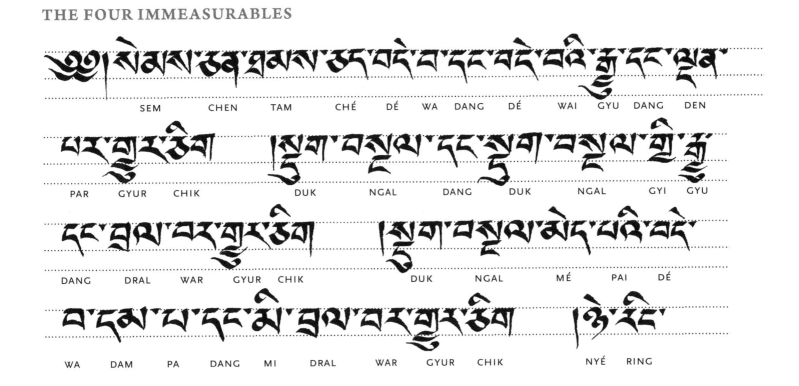

SEM CHEN TAM CHÉ DÉ WA DANG DÉ WAI GYU DANG DEN

PAR GYUR CHIK DUK NGAL DANG DUK NGAL GYI GYU

DANG DRAL WAR GYUR CHIK DUK NGAL MÉ PAI DÉ

WA DAM PA DANG MI DRAL WAR GYUR CHIK NYÉ RING

CHAK DANG NYI DANG DRAL WAI TANG NYOM CHEN PO

LA NÉ PAR GYUR CHIK

May all beings have happiness and the cause of happiness.

May they be free of suffering and the cause of suffering.

May they never be separated from the supreme happiness without suffering.

May they remain in the vast equanimity, free from both attachment and hatred.

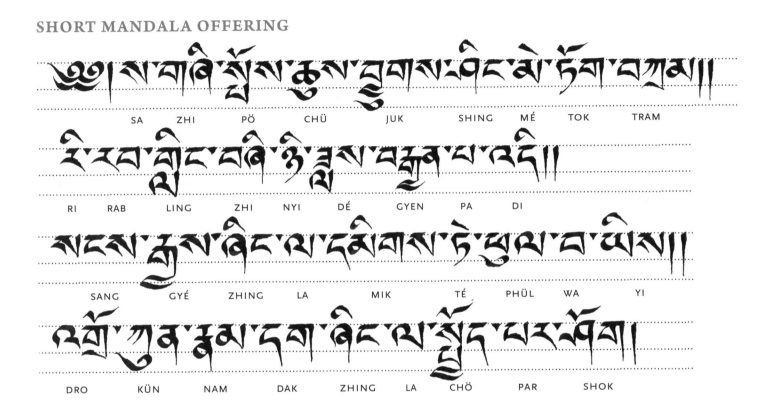

SA · ZHI · PÖ · CHÜ · JUK · SHING · MÉ · TOK · TRAM

RI · RAB · LING · ZHI · NYI · DÉ · GYEN · PA · DI

SANG · GYÉ · ZHING · LA · MIK · TÉ · PHÜL · WA · YI

DRO · KÜN · NAM · DAK · ZHING · LA · CHÖ · PAR · SHOK

This foundation of earth, strewn with flowers and purified with scented water, adorned by Mount Meru, the four continents, the sun and moon: Visualized as a pure buddha realm and offered, may all beings enjoy that perfectly pure realm.

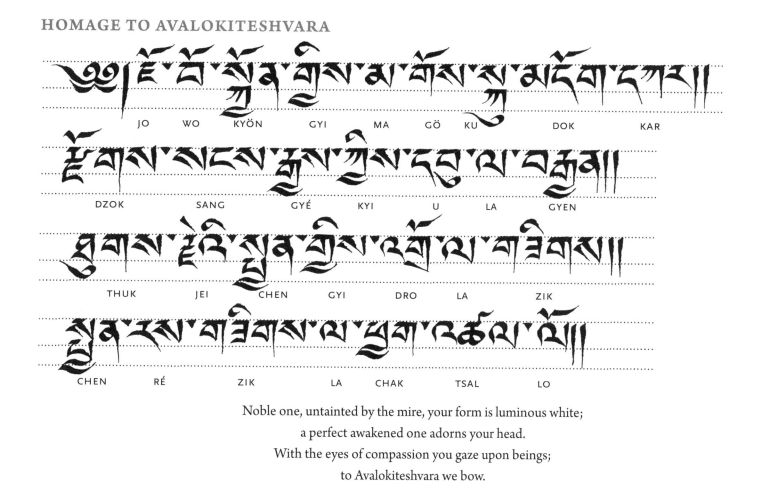

JO WO KYÖN GYI MA GÖ KU DOK KAR

DZOK SANG GYÉ KYI U LA GYEN

THUK JEI CHEN GYI DRO LA ZIK

CHEN RÉ ZIK LA CHAK TSAL LO

Noble one, untainted by the mire, your form is luminous white;
a perfect awakened one adorns your head.
With the eyes of compassion you gaze upon beings;
to Avalokiteshvara we bow.

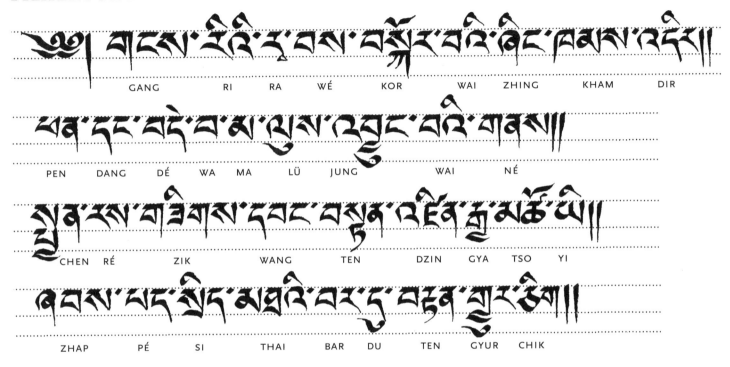

GANG RI RA WÉ KOR WAI ZHING KHAM DIR

PEN DANG DÉ WA MA LÜ JUNG WAI NÉ

CHEN RÉ ZIK WANG TEN DZIN GYA TSO YI

ZHAP PÉ SI THAI BAR DU TEN GYUR CHIK

In this pure realm, surrounded by snow mountains,
you are the source of complete happiness and benefit:
Avalokiteshvara, Tenzin Gyatso,
may you stand firm until the end of existence.

AFTERWORD

ALTHOUGH A PEN is usually used for writing uchen and umé, for certain projects sometimes a brush may be used, and for very formal works sometimes the letters are brushed with real gold leaf that is then burnished to a high gloss. It is said that the very first letters presented to King Songtsen Gampo by Thönmi Sambhota were gold letters on an indigo blue background. This style of writing with both gold and silver on blue or black paper has continued throughout the years, and examples may be seen in museums. Now that you have mastered the basic strokes and characters of uchen, you might consider experimenting with colors or these other options as you expand your practice.

As an example of brush writing, please see the figure of the Four Noble Truths by British calligrapher Tashi Mannox on the next page. The letters were written with a medium-sized flat brush to create the thin letters of this high formal uchen. This work is a wonderful example of how beautiful this alphabet can be, and I hope that it will prove to be an inspiration for you to continue creating great masterpieces of Tibetan calligraphy.

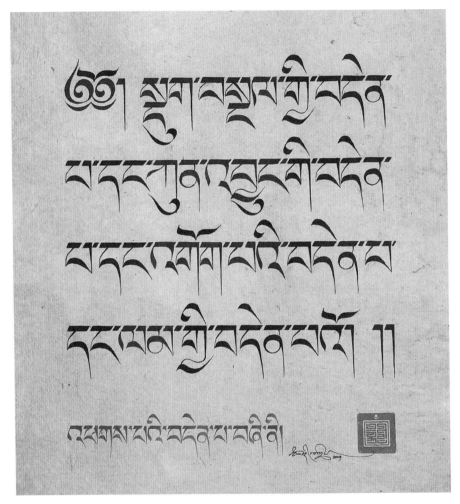

"The truth of suffering, the truth of its origin,
the truth of its cessation, and the truth of the path."
"The Four Noble Truths" by Tashi Mannox.

ADDITIONAL RESOURCES

IF YOU'D LIKE to read further, I recommend the following books:

Stevens, John. *Sacred Calligraphy of the East*. Boston: Shambhala Publications, 1988.

Csoma de Koros, Alexander. *A Grammar of the Tibetan Language*. Columbia, MO: South Asia Books, 1996.

Gega Lama. *Principles of Tibetan Art: Iconography and Iconometry According to the Karma Gardi School*. Darjeeling: Jamyang Singe, 1983.

Rockwell, John, Jr. *A Primer for Classical Literary Tibetan*. Barnet, VT: Samadhi Bookstore: 1991.

Simmer-Brown, Judith. *Dakini's Warm Breath*. Boston: Shambhala Publications, 2001.

Tournadre, Nicolas, and Sangdo Dorje. *Manual of Standard Tibetan*. Ithaca, NY: Snow Lion, 2005.

Hannah, Herbert Bruce. *A Grammar of the Tibetan Language*. New Delhi: Motilal Banarsidass, 1996.

Chandra Das, Sarat. *Tibetan-English Dictionary*. Whitefish, MT: Kessinger Publishing, 2008.

A good resource for art supplies is www.paperinkarts.com; I have found no better resource for hard-to-find materials.

An excellent aid to learning proper pronunciation of the Tibetan letters is at Cornell's Language Resource Center, http://lrc.cornell.edu/medialib/ti/twc.

ACKNOWLEDGMENTS

MANY THANKS to Jamyang Singe for permission to use the excerpt from Lama Gega's *Principles of Tibetan Art*. Much gratitude to Tibetan calligraphy artist Tashi Mannox for the use of his beautiful artwork of Shantideva's verse and the Four Noble Truths.

I would also like to thank Lama Tsundu Sangpo of Darjeeling, India, for his patience and help in teaching me how to write the uchen alphabet with its intricate twists and pen manipulations.

Thanks to my neighbor Sherab (Char Edwards), who lovingly and patiently helped me research the thorny pathways of Tibetan grammar that went into this book, and for her wisdom and many insights. And to her husband, Roger, who took the photos of the hand holding the pen, showing the stroke order of the letters.

Thanks also to Corinne Nakamura, who was an enormous help in getting the initial presentation of this book into a handsome and well-designed form.

Thanks to Tashi Mannox for his many suggestions and help in understanding the various forms of the Tibetan alphabet.

Thanks to Josh Bartok, senior editor of Wisdom Publications, for recognizing and agreeing to the need for such a handbook as this. And to Laura Cunningham, editor, who with great diligence and kindness guided the process of bringing this book into creation.

And finally thanks to my root lama, Kalu Rinpoche, and his dharma heir, Bokar Rinpoche, for inspiring all of us along the path.

ABOUT THE AUTHOR

SANJE ELLIOTT is an artist, calligrapher, thangka painter, professional musician, and world traveler who has studied under Sasaki Roshi, Suzuki Roshi, Bokar Rinpoche, and Kalu Rinpoche. He has helped to found Dharma centers in San Francisco, California, and Portland, Oregon. For many years he taught Tibetan calligraphy and thangka painting at Naropa University in Boulder, Colorado, where he was head of the art department, spending summers in Sante Fe, New Mexico, directing the painting of murals on the walls of the Sante Fe Stupa. He lives in Portland, Oregon.

About Wisdom Publications

Wisdom Publications is the leading publisher of classic and contemporary Buddhist books and practical works on mindfulness. To learn more about us or to explore our other books, please visit our website at wisdomexperience.org or contact us at the address below.

Wisdom Publications
199 Elm Street
Somerville, MA 02144 USA

We are a 501(c)(3) organization, and donations in support of our mission are tax deductible.

Wisdom Publications is affiliated with the Foundation for the Preservation of the Mahayana Tradition (FPMT).